First
Chapter

National Library of Canada Cataloguing in Publication Data

Denton, Don, 1957-
First chapter

ISBN 0-920159-87-7

1. Denton, Don, 1957- 2. Authors, Canadian—Portraits.
3. Portrait photography. I. Title.
TR681.A85D46 2001 779'.2'092 C2001-910555-X

Edited by Richard Harrison
Book design by Vangool Design & Typography
Printed and bound in Canada by Houghton Boston

Previously published material:
Dennis Lee's statement is an excerpt from a longer piece originally published
in *In2Print*, issue 16, summer 1999. Roberta Rees's statement is also an excerpt
from a longer piece first published in *Event: The Douglas College Review*,
volume 25, number 1, spring 1996.

THE CANADA COUNCIL | LE CONSEIL DES ARTS
FOR THE ARTS | DU CANADA
SINCE 1957 | DEPUIS 1957

The Banff Centre Press gratefully acknowledges the Canada Council for the Arts for its support of
our publishing program.

THE BANFF CENTRE

Banff Centre Press Box 1020, Banff, AB T0L 0C0 *www.banffcentre.ca/press*

First Chapter

THE CANADIAN
WRITERS
PHOTOGRAPHY
PROJECT

The Banff Centre
PRESS

∾ DON DENTON ⤺

This book is dedicated to my parents,

Don and Vicky,

who told me to find a career
where I actually enjoyed the work.

Contents

Foreword ∾

In this book are writers from across the country. Some are very well known, others are at the beginning of their careers. There are poets and playwrights and novelists and short story writers. They are young and old and middle-aged.

For the last six years I've had the pleasure of making this series of formal and informal black and white portraits, taking pictures either in the writers' homes, or at readings and other events. This book is by no means a complete survey of the Canadian writing community. We are far too rich a cultural landscape for that. It is a beginning, though. And I hope it is one as intriguing and inviting for you as it is for me.

In addition to their portraits, the authors were asked to consider two questions and answer one or both: "How do you write?" and "Knowing what you've learned at this stage in your career, what would you say to your younger self, starting out as a writer?"

When I develop a roll of film, sometimes I'm surprised by exactly which pictures turn out to be the "good ones," the ones that tell me not just how the subjects look, but how they look at the world. The answers to our questions also have that element of the revealing glimpse. Between the pictures and the words, I hope this book will offer a fresh look at the faces of those whose work you know, and will introduce you to some of the new and talented authors in our country.

Don Denton

January 2001

No book is put together in isolation. That is especially true for a book of photographs and even more so for a book of portraits.

Acknowledgements

Thanks need to go to:

The writers, without whom there would be no book;

George Melnyk who, at his own book launch, grabbed Don Stein, introduced us and told Don he should publish a book of my photographs;

The Banff Centre Press, Don Stein, Lori Burwash, and Lauri Seidlitz;

The staff at the Calgary bookstore Pages on Kensington, especially former owners Peter Oliva and Maria Caffaro for the permanent display of my photographs and for a really great store;

Peter Oliva and Ken McGoogan for their support of this project from the beginning;

Anne Green from PanCanadian WordFest: Banff-Calgary International Writers Festival (www.wordfest.com), who has allowed me to hang around the festival, camera in hand, since day one;

Alma Lee and Dawn Brennan from the Vancouver International Writers and Readers Festival (www.writersfest.bc.ca), who have welcomed me to their festival for the past two years;

David Campion for our endless conversation on why we take photographs;

Sam Tata, John Reeves and Jill Krementz, for the inspiration of their photographs;

And especially Joanne and our three boys Nicholas, Spencer and Cole, who put up with my absences while I'm away taking photographs or in the darkroom printing them.

Peter Oliva

Introduction

I watched this book of photography being assembled on a bookstore wall, one shot at a time, over the course of several years. There was Don Denton, leaning into a shelving unit, angling for a better shot at an author event. A few weeks later he gave me one black & white photo. I don't remember which writer was first caught on film. It may have been Paul Quarrington, sitting on a bench, a contraband stogie in hand, or Michael Turner, profiled with a coffee cup. Whoever it was, their photo was most certainly intimate and surprising in what it revealed.

The photographs multiplied. Within a year, Don seemed to turn our bookstore into a pseudo-blues bar, replete with the photographic evidence of the artists who had haunted the place. Their images faced east, and were hung above a stair rail that led to the second floor. We took the photographs down only once a year, for a slide show when Alberto Manguel came through town.

But by 1999, Don's book, which began with the conjunction of a soybean latte (with chocolate sprinkles) and a Cuban cigar, was literally spread out across the entire store. He had travelled to readings in Banff and Vancouver, and — like an urban anthropologist — he charted the wanderings of Canadian writers in their natural habitat: the dreaded book tour. In Calgary, he became something of a permanent fixture at author events. He also photographed solitary writers, at home or at work. Brought together, these photographs prove a fellowship, a community, and a common affliction that seems to plague each of these writers. That fellowship is, of course, their preoccupation with the written word.

Most importantly, these photos expose some small corner where the words cannot reach. Just a few examples will suffice. Look at Elizabeth Hay and you will see something of her generous heart. Dave Bidini's road-trip, drunken enthusiasm for Life, Life, Life! is in the street, in his eyes, and in the puff of his breath on a winter night. Photographed in her university office, surrounded by novels, dictionaries and student papers, Aritha van Herk seems to hold chaos down with her hands. There are dozens of other discoveries, enthusiasms, and clues that seem to bounce off these photographs and off the words that accompany each intriguing shot.

And here, in words, I found all manner of bookish tips and gossip. I learned who wears their pajamas to work. I now know who writes in front of seals and swans. And I found out who sits down at her desk with a rock stuffed up each nostril.

I witnessed more than one writer's war against time and another's happy belief in the powers of procrastination. Funny: most of these writers seem to love procrastination, at least a little, or they keep it up high on a mantelpiece at one end of the room and admire it from afar. They write along the margins of difficult daytime jobs. They have patient families and secret vices. They have bad backs and thick skins. In fact, they have so many natural gifts and so many ailments that I came away with the thought that writing is sometimes fun, most times humiliating, but almost always it is a ridiculous exercise — a dangerous profession not unlike mountain climbing — and it should only be attempted by mountain goats and fools.

Best of all: I learned that there is no one right way to enter the page, and there are so many different ways to leave it.

"How do you write?"

"Knowing

what you've learned

at this stage in your career, what
would you say to your younger
self, starting out as a writer**?"**

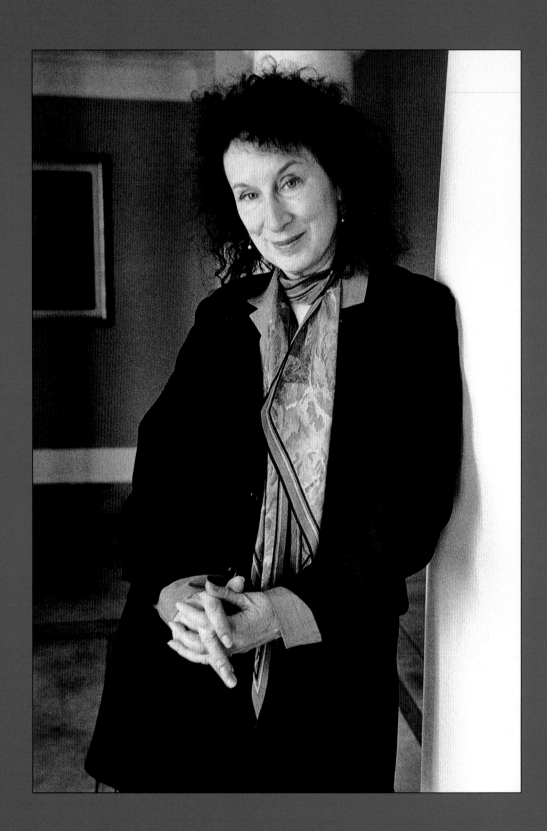

Margaret Atwood

Read and write and read and write.

Toss things out. Get back on the horse that threw you. Develop a good set of back exercises — you'll need them. Get a thick skin, because you'll need that too. ∿

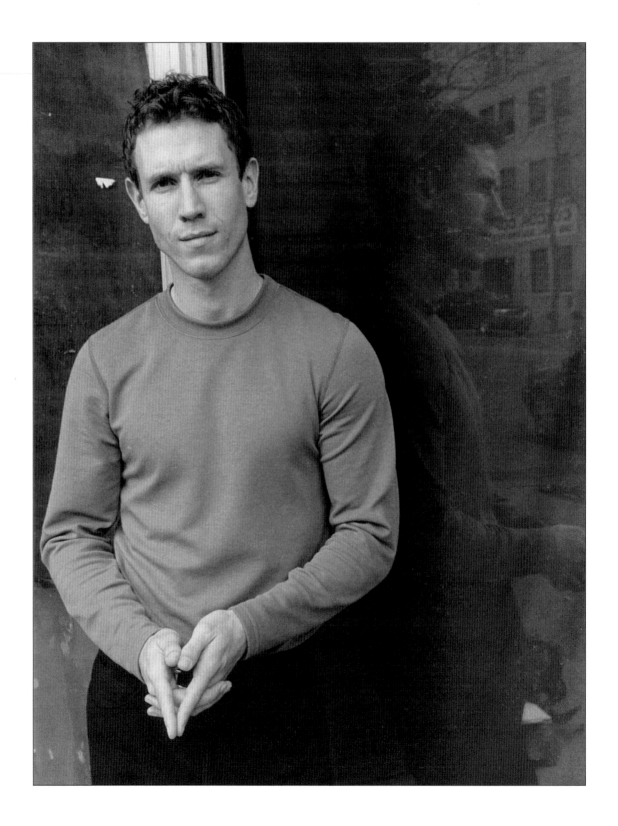

Todd Babiak

As I write this, I have a full-time job with a television station that takes about eleven hours out of each weekday, along with the occasional weekend. This kills any romantic notion I once had about the writer's life. The white-walled workshop looking out over the sea, strewn with back issues of *The New Yorker*. A vase filled with freshly picked flowers on the desk, contemplative walks at mid-morning, leisurely research interviews with peculiar people in peculiar positions, a regular café or pub, dinner parties with writers and intellectuals with a glass of wine in one hand and a cigarette in the other, unshaven, wearing a purple scarf.

The reality guarantees big bags under my eyes and carpal tunnel syndrome. I get up at six each day and arrive at my place of employment by 7:15. I grab a cup of coffee, read my e-mail and check my phone for urgent messages. If there is nothing and the building is still empty by 7:30 and no one is bothering me, I open up my personal file and write. Sometimes I can get away with an hour, sometimes two. Sometimes I suffer without. On the weekends, I write around all necessary social engagements.

Knowing what I've learned at this stage in my career, what would I say to my younger self, starting out as a writer?

Study hard for the LSAT. No.

If I could send a message to myself eight years ago, when I first thought of writing, I would say don't get your hopes up, Sonny. I would force myself to tear all expectations away and to avoid dreaming about a writing career.

The more I think about writing, or think about the sort of life a real writer should be living, the closer I get to breaking my own heart. I should leave this inevitability to other people.

I would tell myself the writing life is not romantic. It is solitary and difficult, filled with rejection and uncertainty. But the writing life is also more rewarding than any other. And if you read hard and write hard and remain determined to learn and improve with each new word, despite powerful obstacles, you will be happy on your deathbed. ❧

I've written in planes, trains, hydrofoils, rickshaws, accordion buses, Port-o-lets, Zeppelins, enormous plastic eggs, Santa suits, church pews, stadium benches, timbered trees, lost boats and mudded huts. I've written standing up, sitting down, keeled over, strung up, peaced out, blissed in, and snowed under. I've zombied down the hallway naked save for tea, cap and slippers and spooled out endless nothings of cardboard genius as often as I've crumpled in a soundless foetal ball only to hiccup three words — "tween, blech, pernicious" — after hours of pinched temples and clamped ass. As I'm writing now, my head is shadowed by stacks of books that wag fingers and sound raspberries and mock my call to the keyboard as if I were a rummy in pop can shoes reaching for a stubbed butt in the gutter, plugging my mug with the wet end of the old smoke, lighting it with a last match, and coming to feel that, despite the rain and darkness and fog and cold and grind of life, in writing I am drunkenly alive. ❧

Dave Bidini

Michele Martin
Bossley

I usually write after my sons are asleep,
curled up on the bed with the laptop against my knees, wrapped in a
fuzzy blanket with a supply of cinnamon gum handy to stop — or at
least curb — the craving for chocolate. I write the way I've always read,
I guess...where I can relax and focus on the story at hand. Reading chil-
dren's books is one of my great passions. I have to discipline myself not
to buy new books while I'm on a deadline, or I may not be strong
enough to resist the temptation.

If I had to give myself a piece of advice when I was starting out, it
would have been to give painstaking attention to the early stages of
each novel. Like so many new writers, I drifted along on the winds of
inspiration, with only a limited idea of where the story was going to
end up. I know there are other authors for whom this works, but it
doesn't work for me. Working with outlines, taking notes about char-
acters and tinkering with the dramatic action before starting a first
draft helps me focus on details in the story that I would otherwise have
overlooked. In order to make a story plausible, to weave the lives of the
characters in interesting and unexpected ways, to lift a story beyond
what is ordinary or cliché, a writer must know how the layers of a story
unfold and use them to his or her advantage. Building a great outline
is the first step toward building a great story. If only I knew this com-
mon sense secret ten years ago! ☾

French wags like to say that Roland Barthes was their best fiction writer in the last part of the twentieth century. Barthes never published any novels or stories, but it is hard to disagree with the French wags. Here is one of the smartest stories he, Barthes, ever told: we decide that before we can make a clean beginning on the big project we have been dreaming of, we have to clean up the little writing and editing jobs that are cluttering up our desks. That will be our life's work — cleaning up that clutter.

That is my experience, too. In fact, that is what I am doing right now as I type these words. But on several occasions I have enjoyed the illusion of the big project. When I am committing a novel, I love the routine of getting up every morning and hitting those keys, and putting a few more slices of typing paper on the pile. In my dream world I am doing that all the time — like a real writer, I imagine. ✿

George
Bowering

Catherine **Bush**

As with the work itself, there's always a chasm between my ideal work habits and the reality. Dream: I get up at dawn, write clear and glorious prose undisturbed for five hours and, done by noon, head out for a long walk. Reality: I stumble out of bed around eight, have breakfast, read the paper, read a second paper, make coffee, get to my desk around ten, check e-mail, check more e-mail. I take breaks. I fight with truckers across the street. Stubbornly, I keep working. Days pass. Years pass. Somehow, miraculously, novels get written.

I'd probably say to my younger self exactly what I was told by an older novelist, when, at 22 and just through college, I set out for New York to become a writer: **Stop if you can.** If you can't stop, keep going until you're incapable of doing anything else. Somehow, even in the direst moments, I'm peculiarly comforted by this mantra. ✍

Wayson Choy

Usually I look distracted when I work on my computer: I'm cast away in that enchanted place where a fictional character springs to life and subverts my planned narrative.

Knowing what I've learned at this stage in my career, what would I say to my younger self, starting out as a writer?

If you intend to be a storyteller, **write and rewrite** until each character breathes life. Hone each sentence so that the words are animated by the character's deepest motives rather than your wishful thinking. Plot lines are worth a dime; living characters, priceless.

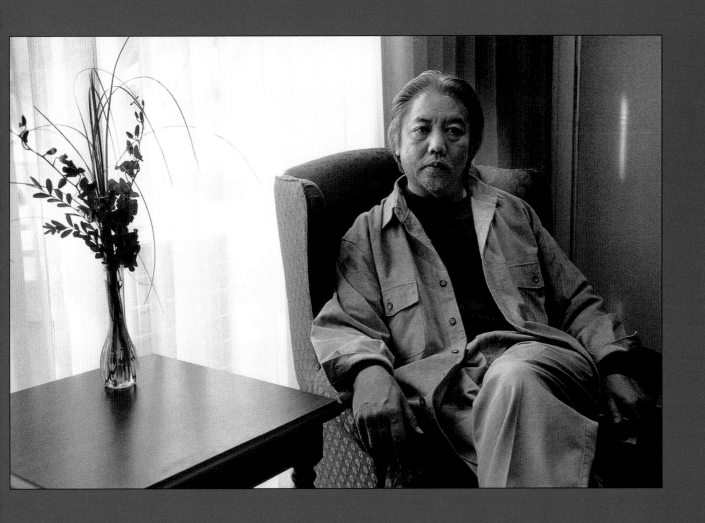

How do I work?

Grimly.

Slowly. Perilously.

With much attention to coffee (Greek, Italian, Swedish) and tea (green and bits of dried weeds). The longer the coffee and tea take to prepare, the better.

Constantly getting up and down.

As though my own bathroom, and my refrigerator, truly fascinated me. Something very important is in there, which I cannot find, and must keep going back to search for.

Staring out the window. Seals. Swans. Occasionally otters. None of them write a damn thing; they are well with the world. They do not even complain about the encroaching suburbs that begin with my face and my eyes, staring out at them.

Looking distractedly in books which no longer inspire me, or inspire too much, so that I must abandon my own sullen work and read into the night.

Sometimes joyously, lost to the intensity of the pleasure, the rushing forward, like a mare pulling at the reins, getting the reins, leaping over creeks and ditches, driven wild with her own power. But that is usually poetry, not prose. And rare. ✑

Karen
Connelly

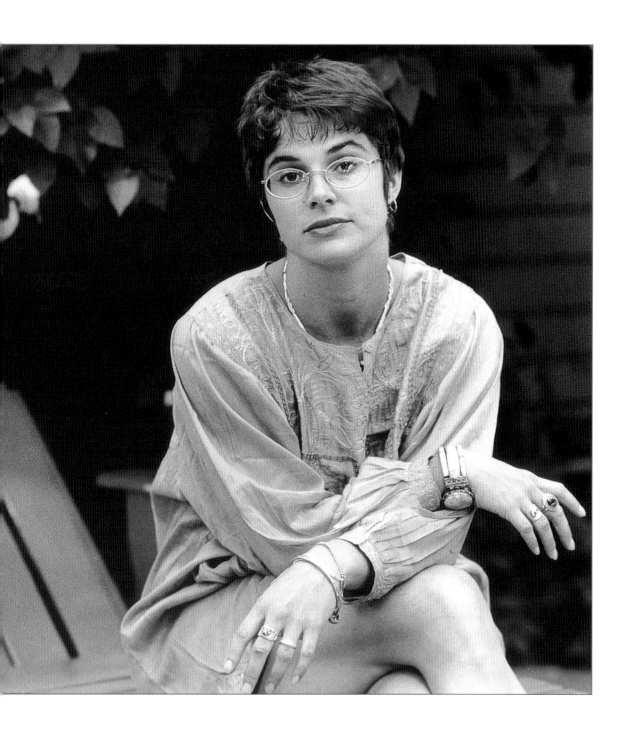

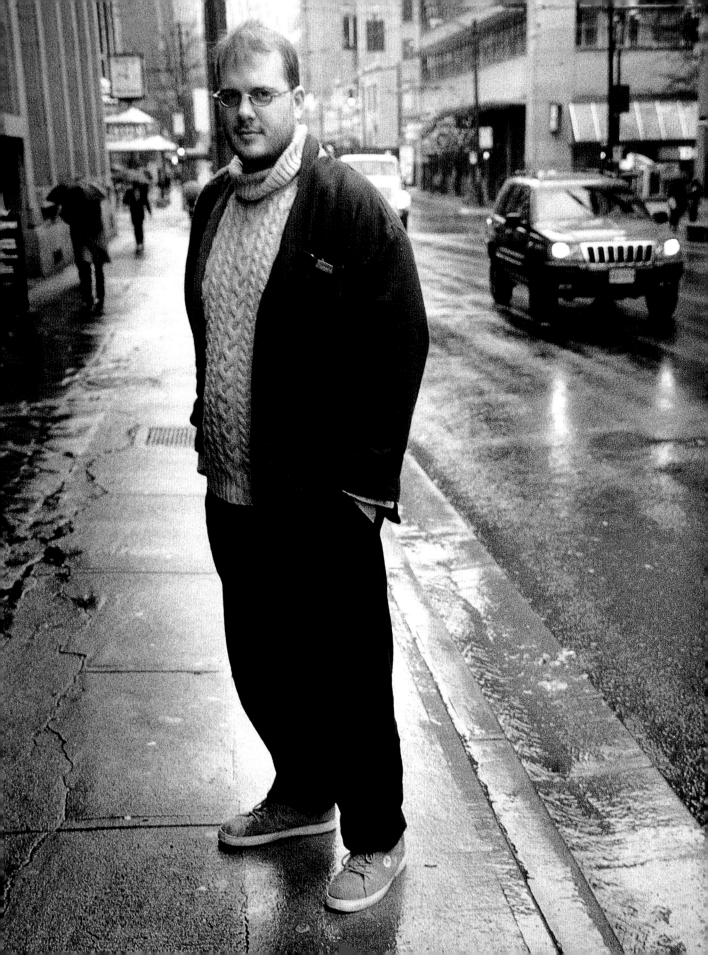

My favourite line in David Cronenberg's *Naked Lunch* is when Bill is being interrogated at the Interzone border and after declaring his occupation as "writer," has been told by the burly border guard to prove it, to which he says "I have a pen." How do I write? My simplest answer is that I write with a pen and later by pecking letters on a keyboard. If I put anymore thought into this question the answer is that I do not know how I write. Sometimes I write at a desk. Sometimes I write in the shower. Sometimes I write while I'm having a conversation and making direct but lazy eye contact with a friend. Sometimes I can't write at all and I convince myself that every word I've ever written has been a magical fluke that will never happen again. What I do know for certain is that for the same reason I was sent to a child psychologist to have my lack of concentration "addressed," and for the same reason I occasionally miss my bus stop on my way home from work, I have become a writer. ∿

Brad Cran

Will
Ferguson

The best thing about being a writer? You get to work in your underwear and scratch yourself whenever you want. Try doing that in your standard office work environment.

Being a full-time writer is a wonderfully lax, fluid lifestyle. And yet, I find that many writers take the process of writing far too seriously — waxing poetic about semi-mystical notions of "creative forces" and "inspirational energy." But the process itself is not complicated. You sit down and you write. It's as simple as that. If you have to muse philosophically about it first, you are in big trouble. I would even go so far as to say that an overemphasis on process is the primary source of most writer's block.

I write anytime, anywhere. I love writing. And if I had any advice to give my younger self, it would have been to quit my day job sooner and take the plunge earlier. ❧

Timothy Findley

I try to write six days a week

and, since 1995, most of my writing is done in the south of France — which protects working hours from the kinds of interruption experienced in Canada. My work begins in the mornings, while my partner, Bill Whitehead, is typing the previous day's handwritten passages. Up until lunchtime, I stay in my own part of the living quarters, thinking about the book as a whole, and about the coming "scenes."

After lunch, I take the freshly printed pages to my atelier — a converted garage. There, I spend the first hour or so on revisions, using a different coloured ink each time I revise the same passage — to facilitate academic research at the National Archives of Canada, where all my manuscripts end up.

I work on producing new handwritten pages until 8:00 or 9:00 in the evening (with a wine-break at 5:00). Then I go down to the house, and over a pre-dinner drink, Bill reads aloud from the new pages. His reading lets me check the rhythm of the words, and his questions may reveal things I mistakenly thought I had already written.

Then — at last — we relax. ❦

Cheryl Foggo

I do a lot of different kinds of writing and I use different methodology, depending on what I'm doing. For television and film, I always work from an outline. For fiction writing, I do much of the work in my head before I ever sit down at the computer. Whatever the milieu or subject matter, if I know what the heart of the story is going in, the work goes much better. I listen to music while I'm preparing and during the work itself. I take so much inspiration and comfort from soul, gospel and jazz artists that I've come to rely on those musicians to take me into the zone where I need to be in order to work effectively.

I would tell my younger self to build a much larger bank account before embarking on a career as a freelance writer. ∿

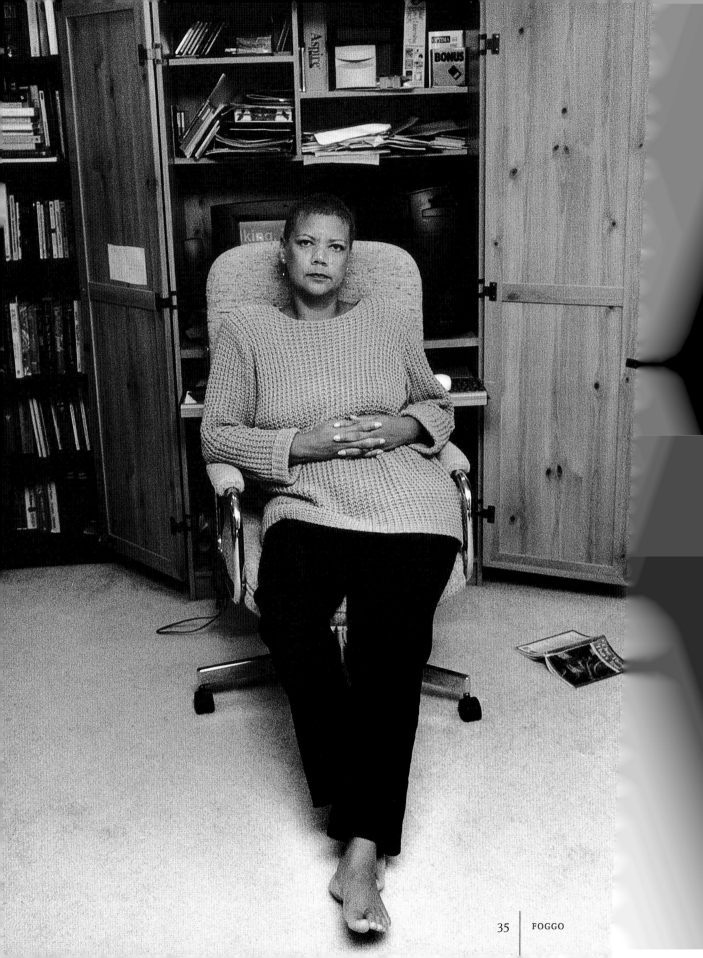

Generally I smoke a huge joint and sit down in front of my computer, formerly my typewriter, and try to make some kind of personal sense out of the madness of everyday life. This often requires intense periods of napping.

Knowing what I've learned at this stage in my career, what would I say to my younger self, starting out as a writer?

Work out more, drink less, don't let the mediocritists pull you down and stop pretending you know everything. ❨

Brad Fraser

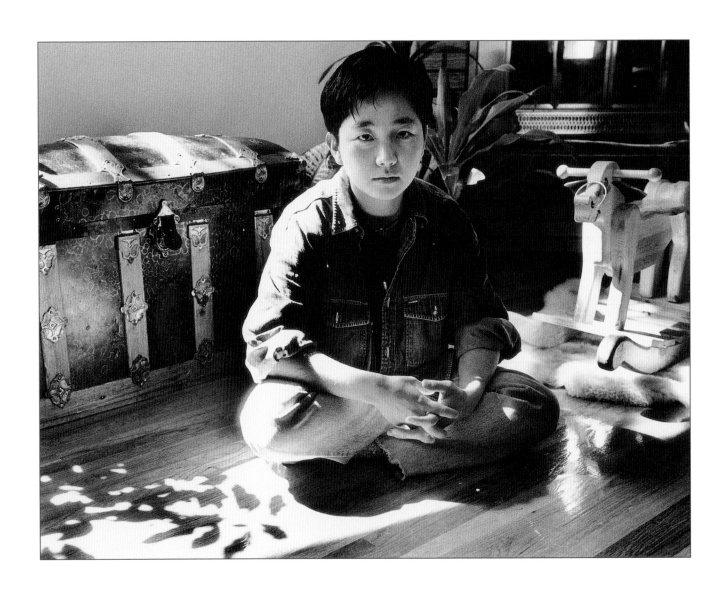

How do I work?

Ear turned, tuned. Whoosh of furnace and the clack of keys, will a child wake? halfway between dreams and nightmare I work, the clock presses between sleep and tired, tho not alone, the night heavy with winter. I know my colleagues, sisters and brothers are writing too, our communities across this cold landscape penning, inking our words the spaces between letters and politics, knowledge and desire and still, and still. Still. A language of change and hope. This working toward. A spiral. ☺

Hiromi
Goto

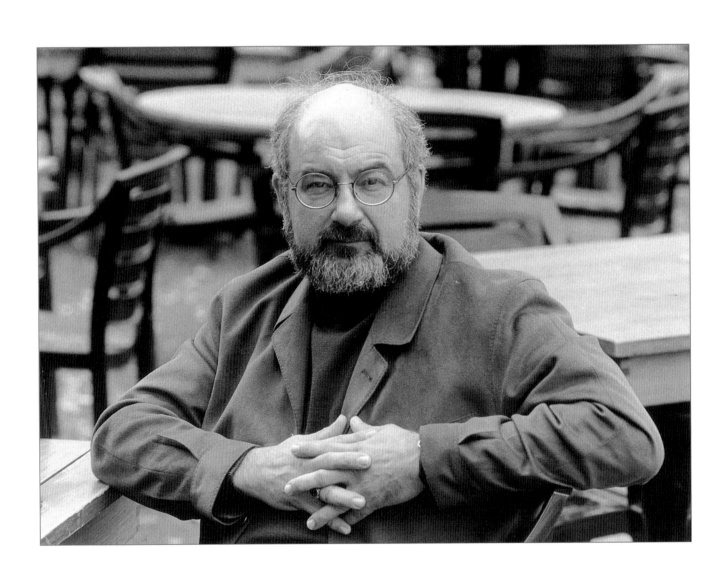

Wayne Grady

After a while, writing ceases to be something you do at specific times of the day, as though there could also be a time when you are not writing. It comes like breathing, or thinking, or feeling. It's something you do all the time, and that doesn't necessarily involve sitting at a desk or a keyboard. Writing can look a lot like chopping wood, or filling the bird feeder, or just staring out a window and noticing the way sunlight falls on the trunk of a white birch. I still do the physical thing, of course; I get up very early, before sunrise, while there is still some life in last-night's coals, make lots of coffee, and sit at the desk and hold the pen. Something comes. Some astonishing thing always comes. I usually shut the computer off sometime after lunch and go out to chop wood or feed the birds.

If I could speak to my younger self I would reprimand him for not having written everything down, for having spent that year in Europe without keeping a notebook, for having waited too long to record certain conversations, for letting that thought get away. And for not having read enough. There are books out there. He would have saved me a lot of time if he had read more of them. But I would also commend him on his curiosity and his memory — not much got by him unremarked. ❧

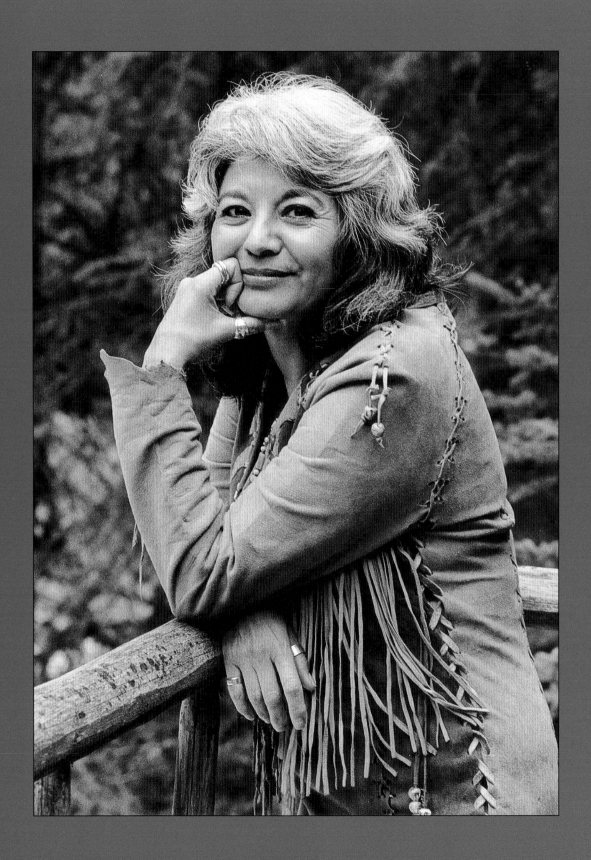

Louise Halfe

I keep a journal that is filled with the daily meandering of thought, activity and observations. Sometimes I receive a whirlpool that bursts with poetry or voices. I will be swept into the waters. I feel blessed, rejuvenated and satisfied. I read somewhere that "writing is sitting in front of a blank page for hours while your forehead bleeds." Writing is both work and passion. I love both the conception and the gestation, which can be very long. The labor is constant and needs to be attended with love — the demands are sometimes maddening. I take great satisfaction in the intercourse between isolation and writing. I must satisfy this insatiable appetite to create a banquet for myself, and ultimately for others. The latter is not the end objective, however: it is most important to create.

For the younger writer: read, read, read. Everything. Learn to be a critical reader. Question. Be open to all you discover. Feel the joy. The pain. The anger. The awareness. The sadness. Write as though you have no audience. Let the audience be yourself and your Creator, however you define it. Listen. Observe. Record. Expand. Go into your fear. Talk with it. Allow it to guide you. Talk with other artists, photographers, sculptors, film-makers, painters, musicians, composers, dancers, writers — know that the process of creativity is familiar to all disciplines and therefore, you are not alone. May you be blessed in your endeavors. Megweetch. All my Relations. ❁

At this stage of my career I'd say

to my younger self, go talk to someone who's written well into their seventies. If I'm lucky enough to become someone like that, here's what I hope I'd say because I'd finally succeeded in living by it: pretty well everything is the reverse of what you knew when you were starting out and knew it all. Love your family first. If you need an artistic reason for this, you don't love them enough. But the puzzle of it is, the quality of the writer you could be is a fraction of the quality of the human being you are. Writing is social. Find the best minds around you and get their help. You might not need it, but your work always does. Writers don't make words: they shape them. Draft and re-draft until the piece is right. You'll know you're on the threshold of being true to your art when you love the drafting process more than you love that first rush of words. In what others say of your work after it is in the world, be thankful for any praise, yet don't think of praise as necessary. In the defeat of any dream, say of it, "is that so?" and move on. The odds are enormously against you ever writing a great poem, let alone a great book. These things are gifts from ungenerous gods. All the work you do in writing is preparing yourself to receive such a gift. ◡

Richard
Harrison

Elizabeth
Hay

I would say to my younger self, Put your nose to the grindstone and don't raise it until you've learned how to tell a story. But would I listen? I tell my present self to write something new every day, at least a page, but do I do it? Usually, I spend several hours a day at my desk with meager results. My desk is an L-shaped arrangement formed by two desks pushed together, both of them covered with far too many papers in which it's easy to get lost. Then I go for a walk to the fruit and vegetable store, or read a book for a while, and my fussy misgivings drop away. Thoughts arise, or fall into place, and writing becomes companionable again. It's possible that I can't have one without the other, I can't have the excitement without the frustration. And it's possible that I will always be a disciplined writer who manages to waste a great deal of time. ৶

Robert Hilles

I usually write a raw first draft at the computer. I leave the work for a period of time and then come back to it and do many revisions. My partner, Pearl Luke, who is also a writer, often gives me input at this point. Later I get feedback from an outside editor. I usually have to do many rewrites of each poem, for I am a writer who tends to overwrite in my first draft and so subsequent drafts require significant paring down. I find the first draft the easiest because there are no rules, just write what comes. All other drafts are hard work and often painful. I find in the end, I have to look at each word in the poem and decide if it is necessary or if there is a better word. As much as possible I want the key words in a poem to be precise. Sometimes luck comes into play in a final draft. I might see a word in someone else's book, and realize that is the exact word I am looking for. Usually it is a simple ordinary word like *attention,* but put in the right place it can do wonders to a poem. Many times, I will start a poem with one intention, but once I begin the first draft, the poem may go in a completely new direction. However, overall, writing for me requires a lot of revising, something I find tiring and frustrating but ultimately rewarding. ❧

Advice to a beginning writer:

Don't waste your energy imagining somebody who knows better than you do how to write your book. If this isn't a way of telling yourself you never will, then it's a way of dreaming a shortcut from Draft 3 to Draft 17. But Draft 4 will never be Draft 17, no matter what you do. Writers should beware shortcuts and saviours. ✿

Greg
Hollingshead

Dennis Lee

Most of your bright ideas about what to write are beside the point. The question is not what you want to write, but what you *can* write. What your imagination is saddled with. *What claims you.* The same applies for every writer, though no two writers are claimed by the same thing.

Learning to write what claims you is like picking up a bow and some arrows, and firing off shots at random. Most of them just drift off into the blue. But every so often, one actually hits something. When it does, you paint a target around whatever it lands on. That's what you were aiming for — even though you didn't know in advance. You pay your dues in the dark. ❦

Nicole Markotic

What do I most want to tell my younger self?

Other beginning writers? This question, of course, begs the larger question of what I want to tell my present self, and other writing colleagues. Because writing, for me, is an ongoing process, an activity, a movement toward and away from. I am moving away from my younger self, but I also approach her — that assiduous and persistent writer, pen in hand (she hasn't heard about computers yet), trying to cram the world onto one page.

"I think," I want to whisper into her fingertips, "that madness is only a version of telling stories." And not because madness is romantic or because artists need to be insane to create, but because what we recognize as a world conveniently divided into order and chaos is really the world unfolding: messy, and flawed, and mad. Our jobs, as writers, is not so much to interpret this crazy world, but to expose it — to ourselves and others — because the history of the daily is only beginning.

Get edgy, and get busy. Flex your pleasure muscles and race across all borders. Play ear and eye games, hurtle far past the horizon, then take one more step. Hesitate in doorways and on fences, and step robustly onto sidewalk cracks.

And don't worry about failing — it's only one step away from creating. ↢

Clem
Martini

I try to ensure that I'm faithful about putting in my time each day at the computer. I try to ignore thoughts regarding the future success or failure of any particular piece of writing as I work on it, because success is dependent on so many whims and variables. And I give myself the gift of working, at least once a day, on a project that I am developing purely for my own enjoyment.

I would say to my younger self, enjoy the writing. Complete, and fully complete, each line of each project. Don't be afraid to edit ruthlessly. Ignore reviews. Truly celebrate the launch or premiere of each book, play or film. Make sure you have a life outside of your writing. ✽

Ken
McGoogan

In the beginning,

I haunted blues bars a la Jack Kerouac. Woke late, scribbled afternoons and said hallelujah to Henry Miller: "If you can do something besides writing, anything at all, then do that other thing." Eventually, from a fire tower in the Canadian Rockies, I looked out across mountains and saw my future: cold-water flats, Kraft dinners, baked beans and dog food. No, wait! On second thought, I would earn my daily bread as a journalist and craft masterpieces by night. Two degrees a-pocket, two babies born, I heard the voice of work-a-day newspapering: "Think again, pal." Wakening to thunder, sweating, I discovered five o'clock in the morning and writing books first. The rest, as they say, is serendipity. ℰ

The relationship between the words

"writing" and "work" captures simultaneously the static and dynamic quality of what a writer does. One creates a "work" in the form of a text that is published as a book. Already we have three words and three interconnected meanings — work, text and book. The work/text/book is both a process and a completion. Sometimes writing is a daily routine; at other times it feels like an amazing game. Usually a text unravels itself on the page step by step, but there are moments when words spill from the keyboard like seeds from a bag. These unnerving, hyperactive episodes are just as draining for the writer as the longer, more drawn-out periods. They both suck up vast amounts of psychic energy.

I have been a writer for thirty years. I now view writing as an attempt to bring the mysterious quality of what we consider to be real into the domain of language. I know that my writing has this quality when I can reread one of my earlier texts and still find it meaningful years later. Writing is a mixture of memory, education, emotion and understanding that comes from the secret structure of one's self. I write about what exists inside and outside of me. My words unite the subjective and objective, thereby creating an illusory oneness for both myself and my readers. ∽

George
Melnyk

Roy Miki

I've always had in circulation a line by poet William Carlos Williams, remembered as "chaos feeds the tree," to help frame the writing practices that have come to shape the boundaries of my work. I've never found the scene of writing, even in the projection of desire it performs, to be all that forgiving in mediating the power of given language forms, especially so for writers who find themselves having to negotiate the reach of discursive norms that inscribe insider-outsider hierarchies based on "race" or other assumptions of difference. Such conditions, I think, have prompted in me a more malleable approach to the larger space of composition as a means of keeping in process several writing projects at the same time — in effect, then, to attempt to work out of a more or less designed absence of preconceived orders. I've found that the tensions generated in this procedure have allowed me to attend to the "local" demands of each writing act while holding to a critical edge. I've needed this edge to maintain the kind of reflexive writing practices that have been important to me during the past two decades. ❦

Sarah Murphy

Sometimes I'm casually walking across a park or I'm driving or just sitting at my computer and suddenly there's a voice that speaks a line so obviously the first line of something I just have to put it down like the first line of *The Measure of Miranda:* "Miranda wasn't able to make love after she'd seen the pictures." Then there are times I'm just sitting at my computer and there's something I want to talk about and it won't come into focus so I just go over it again and again with some kind of mnemonic like, "This is the way it will be." The last way of all is when I just sit down and throw myself at some incident or other the way I am doing for my current work where I just start and then run and run until it's over and I won't give you the first line on that because the first line is the last line it's all one long run-on sentence not even any commas that goes and goes until it stops with the longest one so far about sixteen pages. These are the only ones that give me any trouble at this stage and that's just because the voice is so fast my hands can't keep up and I start writing words like "women" "emowen" because my mind just won't make the leap to the letters any more. But when it's a first line that pops into my head it's usually no trouble at all and I just keep going on day after day and pretty soon there's a story. If it's short then usually it is what it is and with a little tweaking it is what it's going to be, but when it's really long and it's a novel, well then it just keeps growing for two or three drafts until it's ready to be rearranged and cut back, and then there's the pain. And not so much the cutting as the rearranging, because for the longest time it's knowing something has to change and not knowing what, and then the walks across the park are no longer pleasant but aching and fast paced and there's this painful scratching inside my brain until I know what it is which is usually after I've gone to sleep and woken up and then I just go back and do it, separating and rearranging and putting Post-it notes all over the pages because even if I keyboard the writing I have to see it on the page to change it.

I never intended to be a writer. I'd just finished taking down a solo show of my drawings and some first lines kept leaping into my mind and bothering me so I decided to take a few months off being a visual artist to write a book, so I guess I look at the fact that I do write and publish as a small but joyful mystery as well as something of a miracle. Which means there isn't much I'd tell that thirty-something self except to maybe not be quite so scared because there are some roller coasters worth riding. And maybe too, not to quit the visual arts so totally in the intervening years because now that I'm doing both again I know how much I've missed that wordless colourful movement of the hand. Overall though, it's true that others might do it completely differently, and there might be an easier road than the one I picked, because starting so late or quitting for so long, depending on how you look at it, has put me outside my generation both as an artist and a writer. I don't think I could have done it any differently and made it work. So my advice to my younger self is basically the advice I took: Just do it, fear or no. Which would be my advice, I guess, to anyone else too. ✀

Susan Musgrave

I write slowly

I write out of excruciating pain
and an urgent sense of loss.

I write with the ghosts of the Civil Dead
looking over my shoulder.

I write with a rock up each nostril.

I write too fast.

I write so fast one hand trips over the next
to get to the end of the line before it falls off
into darkness.

I write from a place where the darkness
gets darker every day.

I write because it is too terrifying not to.

I write because when I look in the rearview
mirror I see next year's birds in the nests of the
last, and I try to think about how the moment
is all we have coming, and most of the time I fail.

I write because of the Irish proverb,
"Never bolt your door with a boiled carrot"
and because I want to say wise things like that,
once in a while.

I write, most of all, because it isn't there.

Advice to a younger me? Want every-
thing. If you break, break going out, not
going in. Never bolt your door with a
boiled carrot. �

I spend my mornings changing metaphors

like hats in front of a mirror. A great big pool of time sits in front of me. After suffering a series of false starts, I become climatised to the long-distance crawl of putting a book together.

I am aided by a 1950s state-of-the-art, wood-burning computer and a general penchant for navel gazing. If I've forgotten to eat lunch, I am assured a few good pages at the end of the afternoon.

I like it when the day disappears because I sort of do, too. I don't think of the navel, the me, the you, the anything except The Page and that gesture she gave him last night, the way she turned her long neck, turned away from him, and the way the moment seemed to close and lock like a bank vault on New Year's Eve.

I sift through the moment, trying to make sense of these characters and this story. I change it here and there. Whatever the result, it's all fodder for later revisions. And I constantly remind myself that I must get as many words behind me as possible. Otherwise, I'll simply have to write them all over again tomorrow.

> At the end of a day, I turn off the squirrel-driven monitor and go away and read a bunch of books. I read completely impracticable notes on women whose shadows carry the scent of cinnamon. Or I research Egyptian Pharaoh Hounds and learn that they are the only dogs who can blush. This is my real fun: not the writing, certainly not the revisions, but the research. I am searching for gutter-sweet images, for high-wire intoxication, and for the licence to write from one place to another. ✧

Peter Oliva

Stephen
Osborne

How do I write? — only with great difficulty: preparation is everything, of course: read the mail, answer the mail, get the phone, check the appointment book, read a newspaper, read another one, etc. Listen to the news. Better have lunch now, stave off getting hungry later. Arrange the bookshelf, vacuum the carpet. Comb the hair, change the shirt. Research: always something to distract the mind. Eventually the need to learn about the world takes over, and I sit down at the keyboard: only when I'm writing do I learn anything important about the world; and that's what the exercise is all about, in the end. ✸

Between full-time work as a sales representative in the health care industry, and my involvement with Sage Theatre, I am left with very little time and energy to produce poetry. It is in disrupted spaces that I tend to begin most of my poems: at airports, in hotels, in those thirty-minute coffee shop breaks between appointments. Beside my desk I have a stack of receipts and boarding passes with lines scribbled on their backs. A lot of the poems in *pappaji wrote poetry in a language i cannot read* started as thoughts I sounded into a tape recorder, kept in the passenger seat for long drives. I would replay those thoughts in the isolation of hotel rooms and start to frame them into poems. Once that framing had begun I would look for other thoughts to pull into the picture. Once the poems had a general shape that I was satisfied with, then the real work began, that of meticulous editing: replacing words, changing line-endings, reading poems out loud for a better sense of rhythm and cadence. My poetry tends to be very fragmented, very scattered; jumping between languages, time, form, and place. That kind of jitteriness (the shaky hand-held camera) does, I think, lend itself well to the themes of dislocation that I wish to explore. I'm unsure of whether the poetry is a reflection of the way I work, or vice versa. Either way, I hope those scattered thoughts resonate in some way with readers and listeners. ∾

Rajinderpal S.
Pal

Darlene Barry
Quaife

Everything important must begin with a ritual.
The ritual for writing begins with incantation, burnt offerings and blessed water. The radio alarm chants the early hour, the ancient toaster burns the bagels, and tap water is turned into elixir of the gods with the addition of humble ground brown beans. Thus it begins.

The second station of this devotion requires making one's way to the communion room with its altar and icons. Many good books lay open ready for contemplation. The word makes for the kind of serenity out of which creation is wrought. Without the quiet hours of early morning, the benediction of coffee, and the inspiration of ideas made word, it would be impossible to still the chaos that is life long enough to contain it on a pure white page. ✄

I work early in the morning and late at night. I feel I need to be semi-comatose to really write well, and both those times invariably find me thus.

If I encountered the younger me, I would say, "Get out of this barroom. You have work to do." My younger self would no doubt smile blearily and say, "This is research." To which I would have to reply, "Fair enough." ∾

Paul
Quarrington

When I was born

Roberta **Rees**

my father was a jockey and my mother could hit a homerun out of any ballpark. They met at the Stampede Bar & Grill, where my mother who was almost sixteen served fries and gravy and burgers to jockeys from the track. My father who was almost seventeen was so shy the only eyes he could look directly into were a horse's, into the velvety cones deep inside. My mother could sling hash, balance seven plates up her arms, wipe a table in three fast swipes, could love the tiny rider who sang to her in the dark, the tiny baby with eyes like her mother's. Her mother named after the patron saint of music. This has everything to do with the way I write, the content of my writing, the reasons I write, the reasons I often cannot write.

I hear that someone asks of *Eyes Like Pigeons,* a long poem exploring what it means to long for mothering, "Doesn't Roberta know where she ends and others begin?" All winter I hold this question inside, struggle with having exposed myself, exposed people I love. I try to imagine how I could have published this book. Women at readings come to me with their stories, thank me for voicing the sound and feel of our often painfully silent fear and longing and celebration. Yet I can't stop this trembling, this sense of guilt and shame.

A wise friend writes to me about the responsibility that writing out loud brings, how this responsibility can make us anxious because women aren't used to being so public. She mentions the danger in objectifying our own writing, our own selves. She says how important it is to listen to what our bodies tell us. Around the same time, I go to a talk by an Afro-American scholar, Barbara Christian, on Toni Morrison. She talks about Morrison's writing being an act of community healing.

When I was a teenager, someone convinced my father to sing on stage. He had to drink to do it. But once he was up there, he loved it. He got a band together, started singing in clubs and bars. Then he started singing in large halls, cut a small record, had his own television show. Every week I watched him vomit before a performance, take a few drinks, transform himself into the charming, confident, powerful performer everyone wanted to touch. Then he sabotaged his television show, his record contract. Sabotaged them royally. Then he lay on the couch every evening, wouldn't go out with my mother. Then he got cancer and died.

This was how I saw it. The year that I rushed him into the hospital where he was diagnosed with stage IV lymphoma was the same year I quit my full-time teaching job and started taking a creative writing class. By the end of two years of writing classes, two years of accompanying my father as close to death as I could, I decided that art kills you if you do it, kills you if you don't.

Years later I told another wise friend what I'd learned, and she asked if my father had actually quit singing or had he simply quit performing. And I remembered what I had left out of my version. I remember my father sitting in the kitchen, getting that faraway look in his eyes, getting up and going for his guitar, sitting away from the rest of us, holding it close and singing. Eyes closed, singing. I remember how he sang until he physically couldn't. How singing didn't stop him from dying, but kept him alive until he died.

This has to do with how I continue to write, how and why. This, and my mother's fingers combing my hair. ✄

I work five days a week, five or six hours a day, from 9:30 or so to about 3:30 — bankers' hours, as I like to think of them. In that period there may be a lot of down time when I am simply wandering around the house, or checking my e-mail, or playing Free Cell, time that I convince myself is somehow necessary to my creative process, though I may be deluding myself. The greatest obstacle I face when working is overcoming the resistance that comes from self-doubt (hence all the avoidance).

The greatest gift I could offer my younger self, I think, would be my silence. Surviving as a writer, as I see it, is largely a matter of maintaining certain illusions — that writing matters, that people care about writing, that financial success is not important, that you will achieve it nonetheless, and so on. These are the things one tells oneself in order to keep going, even if experience often flies in the face of them. Therefore to have the voice of one's more experienced — and hence more disillusioned — self, speak down to one's younger, ambitious, deluded self might simply be undermining. ∾

Nino
Ricci

David Adams
Richards

My working day is very simple. I usually do a bit of work in the morning, after the kids go to school. Very often however I leave it until the afternoon these days, and work late into the evening. The next morning I go back over my work, make corrections, etc. In that way I work my way through a draft. When the draft is done and in hard copy I read it through, making corrections and changes as I go. Then it is sent off to my publisher. ᔥ

When I began writing I would get up at four, brush my teeth, wash my face, grab my cigarettes and the coffee pot, and go with my dog down the hall to my office. I wrote until seven, and when my then-husband got up to go to work, I went back to bed. It was tough for the first while, but I came to quite like getting up so early. Everything was so still, so quiet and dark. I believed for years that it was absolutely essential for me to write before anything from the new day had a chance to get in. I wanted to keep the move from dream state to writing as free from interruption or distraction as I possibly could, to be able as much as possible to access my subconscious, where I believed all my "stuff" came from. I believed that any kind of interruption would shatter my fragile trance. I guess I see the process as a little less mystical now, and trust it more. Also, my faith in myself is tougher. Though I no longer get up at four, I do try to write at the same time every morning, the same way that I try to run at the same time every day. Conditioning makes it easier for me to discipline myself. ❧

J. Jill
Robinson

Leon Rooke

What I Might Have Said to the Young Me When Starting Out

I would have taken the young writer into a dark corner and said the following:

"How is it we have come to this strange calling, to this enfeebled, humiliating, at times exhilarating, occasionally ennobled, always besieged and penniless profession? If you have been asked what it is that you do, and having replied, 'I am a writer,' you will already have witnessed the doleful response to that timid or bold declaration: the arched brow, the scowl, the look that says, 'My, my, how desperate you must be. I can see by looking at you that you are indeed a pitious, lamentable creature.'

"My friend, Why write? Why, when the labour required is enormous, the hours until a significant result is achieved, endless; when all the words that you render so often sound vacuous or silly, lifeless and wooden, and the interval between the found and the unfound word hangs, as the flags of some nations hang, like a desperate affliction; when confidence is every day your exiled sister; when the work must be done in such murderous isolation that awkward and resolute neurosis is your assured co-partner and pilot; when you must not only write the stuff but be its editor, its judge, and hanging jury; when no one will read what you write, least of all your best friends and last of all your mate, if your mate is unlucky enough to have you; when estrangement from the honest flow of humankind is guaranteed, and frustration before the appointed task is your most abiding company; when the successes arrive in teaspoons, if at all, while the failures arrive at your door like dump trucks; when acclaim stalks the chosen few and those few are demented, oily, and undeserving serpent-headed people unworthy of even your smallest greeting; when you daily mangle your very soul in the delivery of glorious meaningful work and these brilliant and beautiful pages fly out and all you hear in consequence is a poisonous darkness, echo of nothing, flying back; when the chances are high that the smallest public nod of appreciation will brazenly elude you and your devotion is irrelevant; when the reward is a pittance should the stars go awry and that reward arrive in the form of money; when every day requires a spiritual rekindling, new investments of energy and purpose in the face of a thousand defeats, ignominies, and gossipy betrayals, and Time ever hovers at your window and Miss Muse, that rat, is your deadliest, scar-faced enemy; when society, that bumbling urchin, consistently bestows its best on the cheap, the vulgar, the untrue and shoddy, and excellence — this year as in all the years since you were swaddling baby — is yet again deemed out of fashion; when you would give your very life for one dollop of praise that might serve to indicate that you once were here and bearing down on the task at hand, in validation of your ambition and in justification of your small, sordid, warped, hopeless, and terrifyingly vain addiction, Why write? In the face of all this, for God's sake why?

"Well...it's fun. And because you are without choice. Because you know that nothing else brings the news. Nothing else can go so far in the exchange of, and the changing of, lives. Since good writing redeems and resurrects, and since — blue in the face — some of us will go on repeating that. Along the way, it rescues, or relieves, or comforts, or instructs, or mirrors, exposes, illuminates. In no small manner it revives the many. Nourishes the spirit. Affirms, sometimes, the will to persevere. Makes easier that sleep of the innocent dead. Speaks the speech of those from whom there exists the requirement to be heard. It goes where it goes. Camus said this: People die and they are unhappy. That is one reason to do it. They are happy, too, the lucky ones, and that is another. The heart's papers. The goods. Why write? That is why."

That is what I would have said to myself, in that dark corner. And I would have found — and did find — it inspiring. ❧

Advice for Me, Advice for You

I wish — oh, how I wish — I had some useful advice for myself ten years ago. Don't give up is unnecessary. I didn't give up. Write what you believe in sounds trite. Listen harder isn't bad, if only I knew then what I mean now.

How about a specific example. If you're writing a scene where, let's say, a monster comes into the room, what should you talk about first? The room: so long, so wide, so high? The monster itself: its big scaly toe or smelly breath?

No.

The scene with the monster starts the same way as the scene with the hot air balloon, or the scene with the special dessert. Action starts with people. The scene with the monster starts with Amber, who's sitting beside the window feeling sorry for herself because her dad won't let her sleep over at her friend Sarah's that night. Readers aren't interested in the monster. They're interested in the people the monster might eat. 🦶

Richard
Scrimger

Sandra Shields

I go through fads with work. I'm the same way with food. At one time, I wrote standing, my computer perched on a high drafting table. Then there was a period when my laptop lived on a large low coffee table and I sat cross-legged on the floor or knelt, as if in prayer or at an altar, when I wrote. There is no such reverent aspect to my current posture, which is of the totally normal chair-at-desk variety.

> My best variation on a desk was one summer in Calgary when I found an out-of-the-way grove of young trees on the escarpment along the Bow River. I lived nearby and each morning would walk there with my dog, stretch out on the ground and scribble away, no laptop, just old fashioned pen and paper. The writing I did that summer was a bit weird but the place was amazing.

My uneasy relationship with chairs notwithstanding, there are a few constants that define the writing process for me. Always, if I haven't written for awhile, I begin by scribbling in my journal. It's generally nonsense, but it cleans out the pipes and eases me back into that strange abstract space where little black lines on paper come to stand in for the whole world. Once immersed in my work I'm pretty spacey. Writing can, I believe, be a bit like trancing. I'm happiest when I can manage to maintain a predictable rhythm: work for a few hours in the morning, go for a walk, work for a few more hours, take another walk, have supper and, if I'm really keen, work for another hour or two. Though usually by that time I want to touch words that live in a dimension other than the page and will find some excuse for getting out of work and back into life. ∽

I use a heady beat and repeated sonic patterns in my ears, something that drives me like a piston.

Any singing or words will distract me — even excessive sampling of vocal phrases, no matter how meaningless, will ruin it. A pounding electronic beat gives me energy, wakes me up, speeds up my typing fingers, concentrates my mind and isolates me from the world so that I am alone in my brain. Putting on the head-phones is like entering a dark room full of painful lights. The best music for attaining this state is minimalist techno, trance, breaks, and progressive house, in a continuous dj mix. On the day I am writing this, my top five working mixes are: *Decks, EFX* and *909,* by Richie Hawtin (Minus), *Mixmag Live: Richie Hawtin,* by Richie Hawtin (Mix), *Mixed Live: Carl Cox at Crobar Nightclub, Chicago,* by Carl Cox (Moonshine), *Jeff Mills Mix Up Vol.2 (Live at Liquid Room, Tokyo),* by Jeff Mills (Sony Japan), and *Highdesertsoundsystem2,* by John Kelley (Moonshine). By the time this book appears, I will be listening to something else. Those titles are a snapshot of my brain on November 1, 2000. ∾

Russell
Smith

I didn't start writing professionally until I was 37, so I guess the first piece of advice I'd give my younger self would be to start sooner. If I had been as keen on writing as some of the students I've done workshops with are, I would also say, "Don't Stop! No matter what, keep writing." Writing is hard and the tangible rewards are often far between, BUT they are there. And when they come, there is absolutely nothing in the world like them!

I have one other piece of advice that might be worth something. Remember — you are competing with no one but yourself. Strive to be better than you were the last time you wrote something. Try not to fall into that trap of being envious or jealous of what some other writer has accomplished. There will always be writers who are better than you are and writers who are worse. There is little satisfaction in comparing yourself to either. ❦

Bob Stallworthy

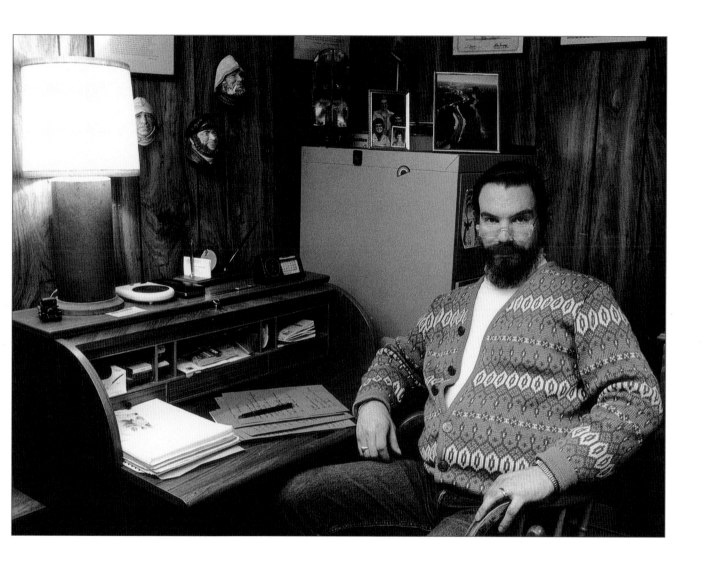

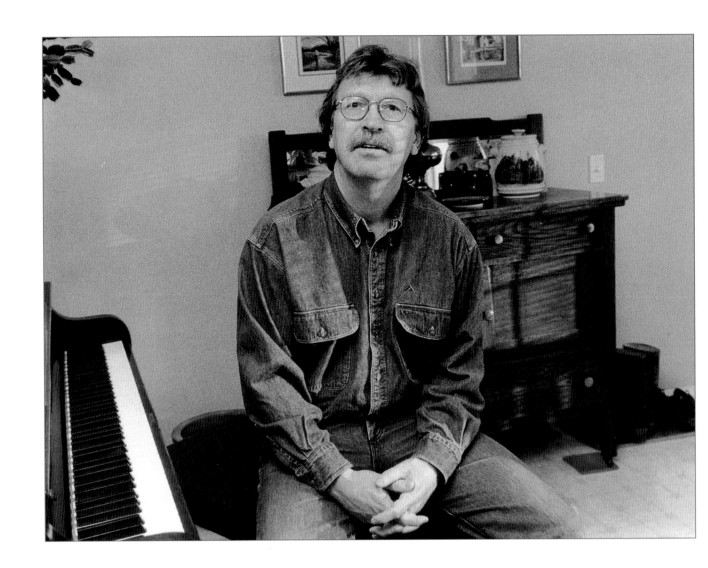

Fred
Stenson

It's hard to know what advice to give my younger self. It might be tremendous advice, but the young person I remember being would almost certainly ignore it. Being young and striking off in idiotic directions wasn't, after all, about not knowing any better. It was about wanting to go off in idiotic directions because those were the quixotic, adventurous directions to go.

I would probably tell my younger self to get a trade, to become an electrician or a plumber, so that, on those days and weeks when I just couldn't bear being a writer any more, or was tired right out by the insane odds against doing financially well at it, I could go off and wire and plumb at union rates. But I remember lots of that kind of advice from my father, who would tell me how good I might do in the world as an engineer, or an agronomist, or a district agriculturist. I remember this advice as a hum in the cab of the truck when we were out driving around the farm from chore to chore, a pleasant drone (my father had a lovely voice) in the background as I dreamt of the maverick, high-wire novels I would write.

But if my younger self was in the mood to listen, I would probably talk about maintaining a connection to the world through physical activity. When you're feeling like a brain on a stick, when your most physical relationship to the world is driving a car, it's a wonderful thing to wield a saw or a hammer, or ride a horse, or even shoot a game of pool. Other writer friends tell me that fly fishing is about the best way there is to get your feet back on the planet after a binge of writing. Simple walking works as well, if you do it fast and look around with all your senses. ⁊

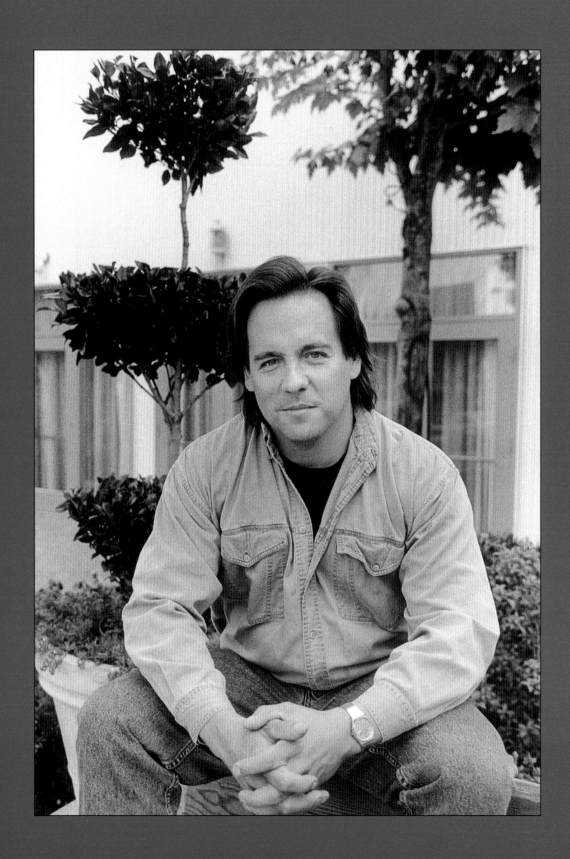

Drew Hayden Taylor

Since I write in so many different fields (theatre, film, documentaries, short stories, journalism, etc.), the way I work differs from medium to medium. Often my plays and short stories come from a single image or idea, and from that point onwards, I just have to flesh the idea out. For instance, what came before the idea or image to create that original inspiration? And then, what comes after it, where does that image or idea finally end up? By constantly asking myself these questions, eventually I construct a story. My second way of creating a story is through the characters. Once I have fully fleshed out my characters, three quarters of the writing is done. I say this because if you really know your characters, they will do most of the writing for you and save you a lot of time.

With journalism and documentaries, it's more taking a larger question or issue, and getting other people to talk about it, then filtering it through your own senses to come up with a synthesis of discussions.

On a more basic level, I write sitting in a room, with no noise or interruptions of any kind. By creating my own little "womb," I can write. I usually don't begin writing something until I have it written out in my head. At one level, I really hate writing, so I try to get it right the first time.

Knowing what I've learned at this stage in my career, what would I say to my younger self, starting out as a writer?

Write sooner.

And don't be so afraid to rewrite. And most importantly, get used to rejection. ৺

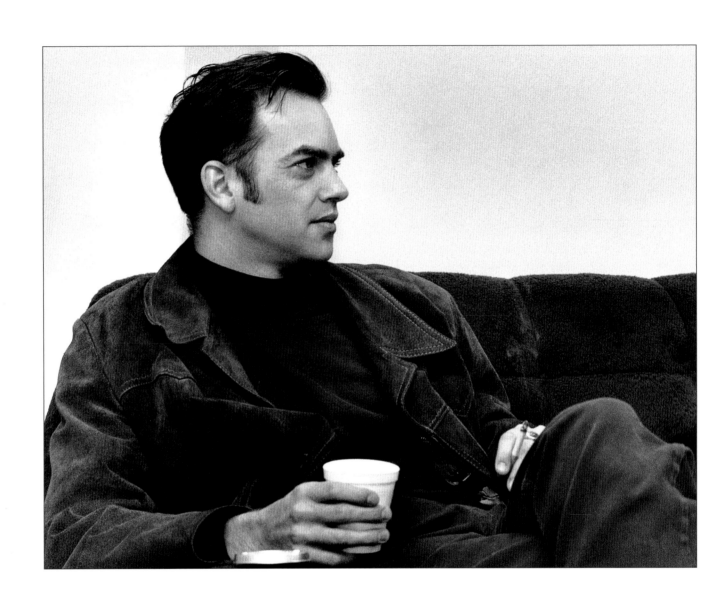

Michael Turner

My first thoughts upon waking are writing.

I am an early-riser, and I am usually up before 7 A.M. Mornings are best for me because my mind is fresh, even though I rarely get to work before mid-afternoon. Procrastination is a big part of my writing process.

I never write for more than three hours at a time. I started writing on a computer in 1995. Before that, I wrote in long-hand, then a manual typewriter for subsequent drafts. If I come across an image (a photo or a drawing or a cultural artifact) that can better express what I do with words, then I'll use it. In that sense, I owe more to the "combine paintings" of Rauschenberg than to the stories of W. O. Mitchell.

If I had any advice for my younger self, given what I know now, it would have something to do with listening, because I was a terrible listener. I would also stress the importance of reading. There is a very tight fit between reading and thinking and writing and listening. ✍

I work in concentrated bursts, getting up early and spending about six hours at the keyboard, then reading and editing, sometimes writing reviews or working on other projects. If I were to give advice to my younger self, I would tell that younger self to make a concentrated life of writing, and to focus entirely on that work. I would also tell that younger self to do exactly what I have spent much of my life doing, reading widely and voraciously. Reading and writing together contribute to a connected energy that is wonderfully exciting and rewarding. ✌

Aritha van Herk

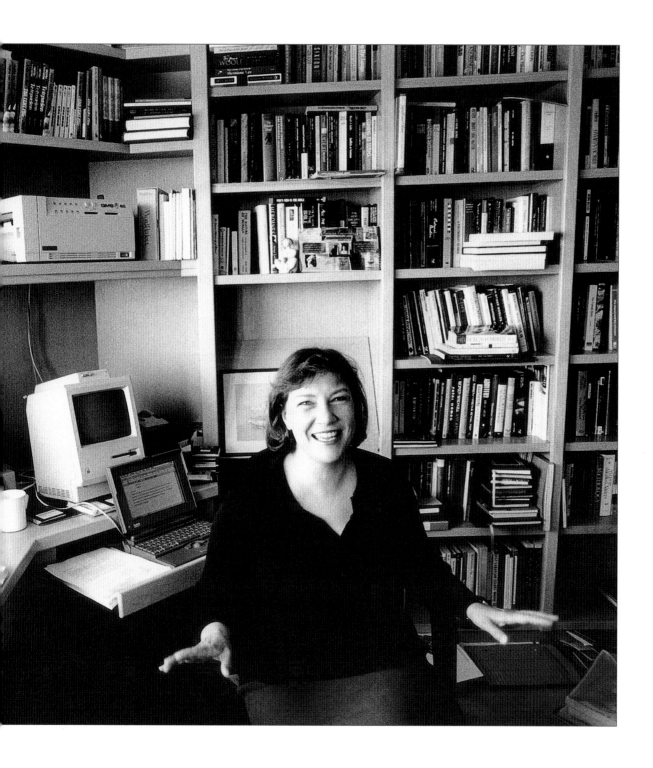

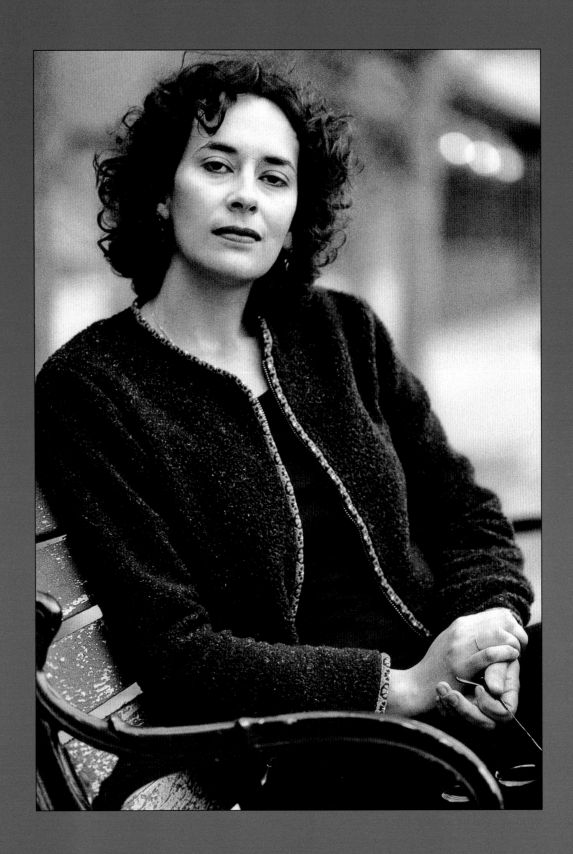

I work between the hours of nine and three, when my children are at school. My desk sits in a corner of the bedroom, my favorite room in the house. It faces a wall, which is good for concentration. But I also write in other places, cafés, the garden, the kitchen table. None of these are as good for the brain, however, as a bit of wall...

What I would say to my younger self is this: forget about fear. 🙢

Erika de Vasconcelos

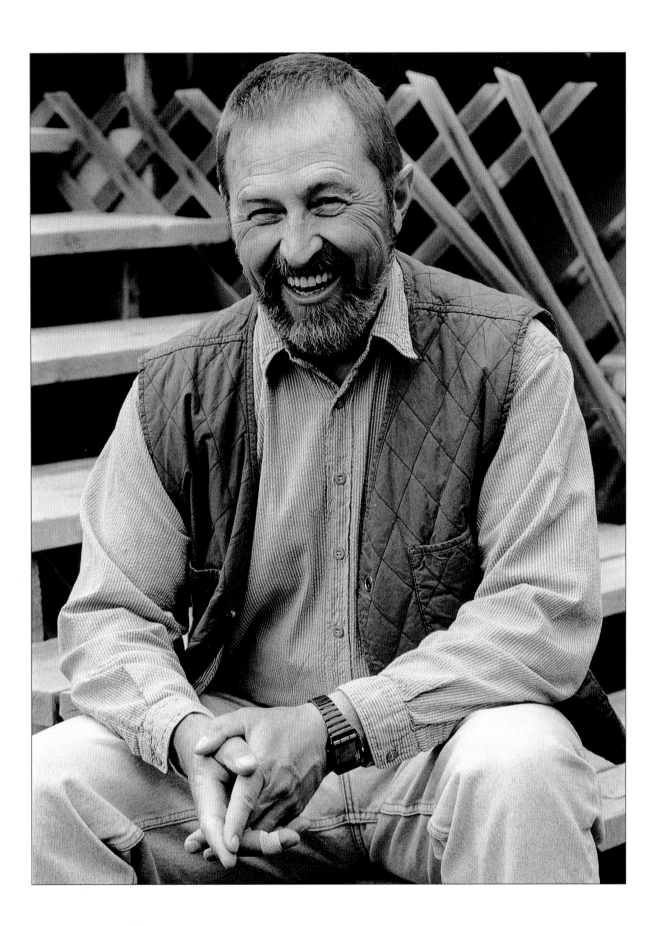

Play.

I keep reminding myself to let go of the sentence (don't get sentenced to the sentence), that know-it-all that wants to tell it all. Play around within the word, between the words. Look at what's left over after grammar. And, I'd tell my younger self, this is serious play, this improvisational fun between the words and syllables and letters and, finally, back inside the sentence too, that this is what turns writing into discovery and into consequence. When I was starting out as a writer, one of my teachers asked, "Why bother?" Now I know why and how to bother; words can and need to make a world. But don't try too hard. I'd tell myself to let go of intention, to go against the grain, and be open to the other, to the differences. And listen. Play it by ear. Now I'm older I can listen to the younger and I hear them play around and stumble on things; let a blunder be a blender, say, let a picture be aperture. ✾

Fred
Wah

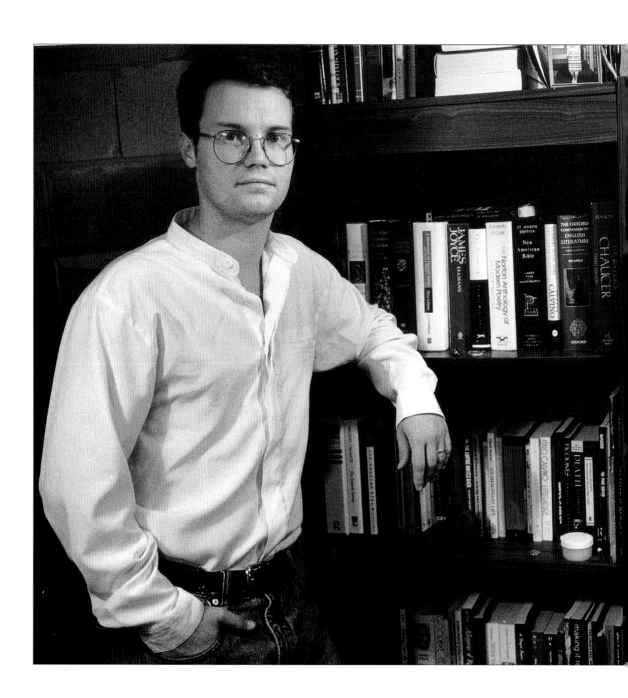

For me, writing is

a physical as well as a mental activity. In fact, on a good day, it takes over every aspect of the self. If I have a full day of writing ahead, I'll start off slowly, lazily even, often getting up from the desk and wandering around the house. Sometimes, for the first hour or so it feels like I'm not getting anywhere, but this is the warming up stage, and seems to be necessary for what follows. Once I've got my stride, I move imperceptibly into a kind of trance in which I'm not aware of anything but the world I'm making out of words, I am in that world, body and spirit, and leave it only reluctantly. It is usually when I'm in this "shamanistic" state that I make discoveries and solve problems. ∽

Thomas
Wharton

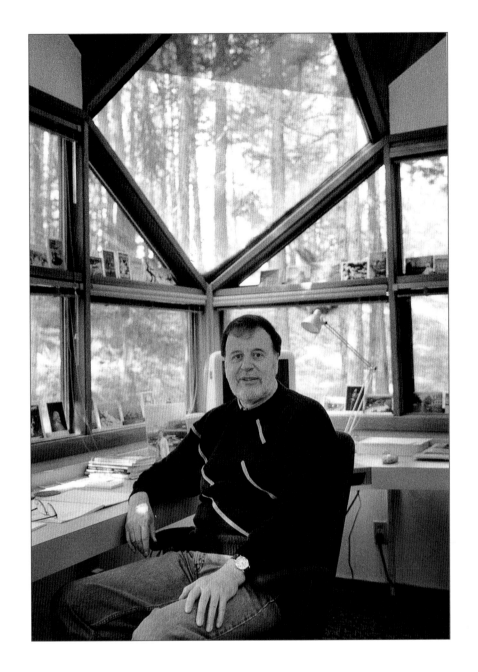

Christopher Wiseman

I find it very difficult to compartmentalize my life. Always have. I seem to need more total focus on one thing, and for more time, than many writers, and that means problems of place and productivity. Until I early-retired, I had spent my life teaching in universities, where personal rhythms were, of necessity, subservient to the intense demands of the academic year. Teaching creative writing and English — as well as the weight of marking, preparation, committees, reading/research, etc. — made it impossible for me to write during terms, with all those other writers' voices in my head, and I had to fit my own work, together with academic research, into vacations. So I have always written in intense bursts, with long fallow periods (where many notes get written, ideas thought about, poems/stories tried out in my head). Not for me, and I regret it, the ability to use a spare half hour to start a poem — I need total concentration, no need to look at my watch, nothing coming up.

My solution over the years has been to write in retreats, where I can focus fully. This has been expensive and has also needed a supportive, understanding and utterly generous wife. The first draft is, for me, the killer, the thing I can't fit in short periods, the baleful taunting gaze of the blank page leading to paralysis, and only at a retreat can I cope with it. After getting a draft done, I can revise at my leisure, but that uninterrupted time to focus, to forget the phone, shopping, lunches, coffees, readings, putting out garbage, loading dishwasher, etc. I have only ever found in retreats.

The Saskatchewan places, very dear to me, at Fort San and St. Peter's Monastery, have been my first-draft home seven or eight times. Hawthornden Castle in Scotland gave me a unique month. But increasingly it's the Leighton Studios at The Banff Centre that have become my writerly home, my place of first drafts. I have stayed there every year since 1986 (for periods ranging from eight days to three months), and have spent well over a year of my life in that thinning pinewood. Around 75–80 per cent of my last four published books were written in the Evamy Studio, which I find ideal for writing, and which (for it's not cheap) I pay for with my Public Lending Right money, plus all the toonies I get in change. Now that I'm free of university demands, I try to get there for a month each year, which translates into as much first draft writing as I'd do in a year at home. I can then revise those drafts at leisure.

There are commissioned poems, and some first drafts done at home, but always I gravitate to a place where I am totally free to write and do nothing else, to be alone with the remembered and imagined people, the words, the formal choices, the wrestling with angels/devils that is first draft writing. Banff is just an hour from home, but is a different world and one that pulls writing out of me. I need it. I wonder, often, if this shows some kind of neurosis. Or whether, perhaps, it's because my desk at home has always been where I've done academic work, marking, and such non-creative things, whereas retreats have only been for creative work. I don't know. I don't ever believe a writer who claims to know how and why he/she writes. I just know that Banff, Saskatchewan, Hawthornden, a blank anonymous motel room even, but especially Banff, can reveal to me what it is I'm writing inside myself, and can, when I'm lucky, coax out of me, often in startling profusion, those dreaded first drafts. And for this I'm profoundly grateful. 🌿

Profiled Authors

MARGARET ATWOOD is the author of more than 25 books of poetry, fiction and non-fiction, and her work has been translated into more than 30 languages. Her newest novel, *The Blind Assassin* (McClelland & Stewart), was published in September 2000. She lives in Toronto.

TODD BABIAK's first novel, *Choke Hold* (Turnstone), was published in 2000. It won the Writers Guild of Alberta Henry Kreisel Award for Best First Book and was shortlisted for the Rogers Writers' Trust Fiction Prize. His second novel is tentatively titled *Small*. Babiak is an entertainment writer at the *Edmonton Journal*.

DAVE BIDINI has written two books — *On a Cold Road* (1998) and *Tropic of Hockey* (2000) — both published by McClelland & Stewart. He lives in Toronto with his wife and daughter.

MICHELE MARTIN BOSSLEY was born in Boston, Massachusetts, but grew up in Calgary from the time she was five. Bossley has published eight juvenile novels with James Lorimer & Company. Four of these titles, *The Perfect Gymnast* (1996), *Taking a Dive* (1997), *The Winning Edge* (1998) and *Queen of the Court* (2000), have been selected by the Canadian Children's Book Centre for the Our Choice list. She is currently working on *Power Play*, a hockey novel planned for fall 2001.

GEORGE BOWERING was born in 1936 in Penticton, B.C. Among numerous other awards, he won the Governor General's Literary Award for poetry in 1969 for *The Gangs of Kosmos* (House of Anansi 1969) and *Rocky Mountain Foot* (McClelland & Stewart 1969). He then won the Governor General's award for fiction in 1980 for *Burning Water* (General 1980). Most recently, Bowering won the bp Nichol Chapbook Award for poetry in 1991 and 1992 and the Canadian Authors' Association Award for Poetry in 1993.

CATHERINE BUSH is the author of two novels: *The Rules of Engagement* (Harper Perennial Canada 2000), a *New York Times* Notable Book and a Best Book of the Year as chosen by the *Globe and Mail* and the *LA Times*, and *Minus Time* (Harper Perennial Canada 1993), which was shortlisted for the 1994 SmithBooks/*Books in Canada* First Novel Award and a City of Toronto Book Award. Her non-fiction has appeared in publications such as the *New York Times Magazine* and the *Globe and Mail*. She lives in Toronto.

WAYSON CHOY was born in Vancouver and was the first Chinese person to enroll in the University of British Columbia's creative writing course. He moved to Toronto and, since 1967, has been a professor at Humber College and a faculty member of the Humber School for Writers. His award-winning works include *The Jade Peony* (Douglas & McIntyre 1995), which was co-winner of the Trillium Book Award, and *Paper Shadows: A Chinatown Childhood* (Penguin 1999), which won the Edna Staebler Creative Non-Fiction Award.

KAREN CONNELLY is the author of seven books of poetry and non-fiction. She is the winner of the League of Canadian Poets Pat Lowther Memorial Award and the Governor General's Literary Award for non-fiction, which she received for *Touch the Dragon: A Thai Journal* (Turnstone 1992). She is currently working on

a novel and a collection of essays about Burma. Her most recent book of poetry is entitled *The Border Surrounds Us* (2000), published by McClelland & Stewart.

BRAD CRAN is a poet, essayist and photographer. He is the publisher of Smoking Lung Press, a co-founder of the Vancouver based Stillworks photography collective, a contributing editor at *Geist* magazine and the editor of the anthologies *Hammer & Tongs* (Smoking Lung 1999) and *Why I Sing the Blues* (with Jan Zwicky, Smoking Lung 2001). His first collection of poetry, *The Good Life*, will be published in the spring of 2002 by Nightwood Editions.

WILL FERGUSON's debut novel, *Generica* (Penguin 2001), was hailed by the *Globe and Mail* as an "uncompromising and brilliant satire." Ferguson is also the author of eight non-fiction works, including *Why I Hate Canadians* (Douglas & McIntyre 1997), *Bastards & Boneheads* (Douglas & McIntyre 1999), and *Canadian History for Dummies* (CDG 2000). He once hitchhiked the length of Japan, following the cherry blossoms north, as retold in his travel narrative, *Hokkaido Highway Blues* (Soho 1998). Ferguson currently lives in Calgary with his wife and young son.

TIMOTHY FINDLEY, born in Toronto in 1930, now divides his year between Stratford, Ontario, and Provence, France. After an international career as an actor, he came to prominence as a writer with his 1977 novel, *The Wars* (Clark-Irwin). Since then, his fiction, plays, memoirs and film and television scripts have won numerous awards. Findley is an Officer in the Order of Canada, a member of the Order of

Ontario and, in France, Chevalier de l'Ordre des Arts et des Lettres.

CHERYL FOGGO has been published and produced as a journalist, screenwriter, poet, playwright, writer of fiction and non-fiction and young adult novelist. Recipient of numerous awards for her work and achievements, her first young adult novel, *One Thing That's True* (Kids Can 1997), was shortlisted for a Governor General's Literary Award for children's literature and the Mr. Christie's Book Award. *One Thing That's True* has been adapted to the screen and is now in development for television.

BRAD FRASER's works have been internationally produced and acclaimed. His hit play *Unidentified Human Remains and the True Nature of Love* (NeWest 1996) premiered in 1989. It has since been produced and translated worldwide. The film version of the play, *Love and Human Remains*, won Fraser a Genie for Best Adapted Screenplay in 1994. His latest play is *Snake in Fridge* (NeWest 2001). Fraser is currently directing the film adaptation to his Governor General's Award nominated script *Poor Super Man*. He maintains a website at www.bradfraser.com.

HIROMI GOTO is an award-winning author whose short stories and critical writing have been published in numerous magazines and anthologies. Her first novel, *Chorus of Mushrooms* (NeWest 1994), was recipient of the Commonwealth Writer's Prize for Best First Book, Canada and Caribbean Regions, and the co-winner of the Canada-Japan Book Award. Goto's latest novels include *The Kappa Child* (Red Deer 2001) and *The Water of Possibility*

(Coteau 2001). She is also a writing instructor, an anti-racism advocate and the mother of two children.

WAYNE GRADY was born in Windsor, Ontario, in 1948. He has worked and written for many Canadian magazines, including *Saturday Night*, *Harrowsmith*, *Equinox*, and *Toronto Life* — mainly in the fields of science and nature. He has written eight books, translated several novels (from French) and is an anthologist. He is married to the writer Merilyn Simonds and lives near Kingston, Ontario.

LOUISE BERNICE HALFE, Sky Dancer, was born in Two Hills, Alberta, and was raised on the Saddle Lake First Nations Reserve. Her first book of poetry, *Bear Bones & Feathers* (Coteau 1994), was shortlisted for the Spirit of Saskatchewan Award, the Saskatchewan First Book Award, the League of Canadian Poets Gerald Lampert Memorial Award and the Pat Lowther Memorial Award. In 1996 the book won the Milton Acorn People's Poetry Award. Halfe's second book, *Blue Marrow* (McClelland & Stewart 1998), was shortlisted for numerous awards, including the Governor General's Literary Award for poetry.

RICHARD HARRISON's *Big Breath of a Wish* (Wolsak & Wynn, 1999), poems about his daughter learning to speak, was a Governor General's Award nominee. His *Hero of the Play* (Wolsak & Wynn 1994), poems in the language of hockey, was the first book of poetry launched at the Hockey Hall of Fame; its reading at the Saddledome introduced him as the University of Calgary's Markin-Flanagan Writer-in-Residence. Also an essayist and editor, Harrison teaches English and Creative Writing at Mount Royal College.

ELIZABETH HAY was born in Owen Sound, Ontario. She has worked as a broadcaster for CBC Radio in Yellowknife, Winnipeg, and Toronto. She lived in Mexico for a time, and for several years in New York City. Her novel *A Student of Weather* (McClelland & Stewart 2000) was a Giller Prize finalist. Her story collection *Small Change* (Porcupine's Quill 1997) was a finalist for the Governor General's Literary Award. She lives in Ottawa.

ROBERT HILLES lives in Calgary and Sooke, B.C., with his partner Pearl Luke. He has published numerous award-winning books of poetry, fiction, and non-fiction. His book of poetry, *Cantos from a Small Room* (Wolsak & Wynn 1993), won the 1994 Governor General's Literary Award. A new book of poems, *Higher Ground* (River Books), appeared in the spring of 2001. He recently finished his second novel called *A Gradual Ruin* and is at work on a new novel called *Shining Down Like Water*.

GREG HOLLINGSHEAD has published two novels and three collections of stories. His collection *The Roaring Girl* (Sommerville House 1995) won the Governor General's Literary Award for fiction. His novel *The Healer* (Harper-Flamingo 1998) was shortlisted for the Giller Prize and won the Rogers Writers' Trust Fiction Prize. He teaches English literature and creative writing at the University of Alberta and is Director of the Writing Studio Programs at The Banff Centre.

DENNIS LEE was born in Toronto in 1939. His most recent poetry collection is *Nightwatch: New and Selected Poems* (McClelland & Stewart 1996). His latest children's book, *The Cat and the Wizard,* illustrated by Gillian Johnson, will be out in the fall of 2001 from Key Porter.

NICOLE MARKOTIC is a poet and fiction writer. She teaches English literature and creative writing at the University of Calgary, is poetry editor for Red Deer Press, and is on the Tessera feminist collective. She has published three books — *Connect the Dots* (Wolsak & Wynn 1994), a collection of prose poems; *Yellow Pages* (Red Deer 1995), a novel; and *Minotaurs & Other Alphabets* (Wolsak & Wynn 1998), her most recent poems. She is currently completing a novel and a book about the representations of the problem body in film and literature.

CLEM MARTINI is a professor in the University of Calgary drama department and an award-winning playwright, screenwriter and writer of short fiction. He is an artistic associate at Lunchbox Theatre, co-author of the International Institute for Research of the One Act Play, and he works with troubled youths as a drama consultant through the charitable organization, Woods Homes. His published works include *A Three Martini Lunch* (Red Deer 2000), *Illegal Entry* (Playwrights Union 1999) and *Something Like a Drug — The Unauthorized Oral History of Theatresports* (Red Deer 1995).

KEN MCGOOGAN, formerly books editor at the *Calgary Herald*, has published six books in the past decade. His latest is *Fatal Passage: The Untold Story of John Rae, the Arctic Adventurer Who Discovered the Fate of Franklin* (Harper-Collins 2001). Previous books include the award-winning *Canada's Undeclared War: Fighting Words from the Literary Trenches* (Detselig 1991) and several novels, including *Kerouac's Ghost* (Robert Davies 1996), which was translated into French. Based in Calgary, where he writes, edits, teaches and consults, McGoogan is working on a second book of creative non-fiction.

GEORGE MELNYK is an Alberta author and professor of Canadian studies at the University of Calgary. He has published numerous books on western Canada, including a trilogy of essay collections, of which the latest is *New Moon at Batoche* (Banff Centre 2000). His pioneering two-volume *Literary History of Alberta* (University of Alberta 1998, 1999) has become a benchmark for cultural studies in Canada. He lives in Calgary.

ROY MIKI is a writer, poet, and editor who teaches contemporary literature at Simon Fraser University. He was born in Winnipeg but relocated to the west coast in the late 1960s. As well as editing two journals and several books, his publications include *Justice in Our Time: The Japanese Canadian Redress Settlement* (Talonbooks 1991), co-written with Cassandra Kobayashi, and *Broken Entries: Race, Subjectivity, Writing* (Mercury 1998). A book of poems, *Surrender*, is forthcoming from Mercury Press. Roy lives in Vancouver's Kitsilano district.

SARAH MURPHY is of Choctaw, Irish, English, Hispanic and German heritage and has lived in the United States, Mexico and Canada. She is a translator, interpreter, teacher, community activist, prize-winning visual and performance artist and critically acclaimed author of three novels and two collections of short fiction. Murphy's work has been shown or published in Canada, the United States, Australia, Nicaragua, Cuba, Mexico and the United Kingdom, where she has also been an international writer in residence.

SUSAN MUSGRAVE's third novel, *Cargo of Orchids*, was published in September 2000 by Knopf. Her most recent collection of poetry is *What the Small Day Cannot Hold: Collected*

Poems 1970-1985 (Beach Holme 2000). She has been nominated for, and has received, awards in five different categories of writing: poetry, fiction, non-fiction, personal essay, children's writing and for her work as an editor.

PETER OLIVA was born in Eugene, Oregon, and grew up in Italy and western Canada. Now based in Calgary, his first novel, *Drowning in Darkness* (Cormorant 1993), was highly acclaimed and won the Writers Guild of Alberta Henry Kreisel Award for Best First Book and was shortlisted for an F. G. Bressani Prize. Oliva's 1999 novel, *The City of Yes* (McClelland & Stewart), won the Rogers Writers' Trust Fiction Prize, the F. G. Bressani Prize and the Writers Guild of Alberta Georges Bugnet Award for Fiction.

STEPHEN OSBORNE was born in Pangnirtung in 1947, grew up in Edmonton and Kamloops, and now lives in Vancouver. Since 1990 he has been the editor of *Geist* magazine and has published numerous essays in popular and alternative magazines. His recent book is *Ice and Fire: Dispatches from the New World* (Arsenal 1999) and he is now at work on a book to be called *For You Who Grow Pale at the Mention of Vancouver: A Novel.*

RAJINDERPAL S. PAL was born in India, grew up in England, and has called Calgary home for over twenty years. Pal's love of poetry and language began at a very young age. When his poet father died, Pal inherited not only his father's bedroom, but also his collection of books. Part of this story is told in Pal's first collection of poetry, *pappaji wrote poetry in a language i cannot read* (TSAR 1998), winner of the 1999 Writers Guild of Alberta Henry Kreisel Award for Best First Book.

DARLENE BARRY QUAIFE's novel *Bone Bird* (Turnstone 1989) won the Commonwealth Writers Prize for Best First Book, Canada and Caribbean Regions. Her novel *Days & Nights on the Amazon* (Turnstone 1994) was voted A Book for Everybody by the Canadian Booksellers Association. *Death Writes: A Curious Notebook* (Arsenal 1997), a book of popular culture on a ubiquitous theme, has been called "an insightful avant-Goth perspective — the world according to Death." Quaife's latest novel, *Polar Circus* (Turnstone 2001), is an eco-thriller. As a freelance writer, she has contributed to newspapers, magazines and journals.

PAUL QUARRINGTON was born in Toronto and still lives in the city with his family. Quarrington has won numerous awards for his work, including the Governor General's Literary Award for fiction for *Whale Music* (Doubleday 1989), which was made into a successful motion picture. His second novel, *King Leary* (Doubleday 1987), won the Stephen Leacock Medal for Humour in 1987. He has also won awards for his writing for the television series "Due South" and for his screenplay for *Perfectly Normal.*

ROBERTA REES grew up in the Crowsnest Pass, a coal-mining community in the Rocky Mountains of southern Alberta. She now lives in Calgary, where she teaches creative writing. Her first book, *Eyes Like Pigeons* (Brick Books 1992), won the Writers Guild of Alberta Stephan J. Stephannson Award for Poetry and the League of Canadian Poets Gerald Lampert Memorial Award. Her most recent novel, *Beneath the Faceless Mountain* (Red Deer 1994), won the Alberta New Fiction Competition and the Writers Guild of Alberta Georges Bugnet Award for Fiction. Rees is currently working on a novel and a book of prose-poems.

NINO RICCI is the author of a trilogy of novels: *Lives of the Saints* (Cormorant 1990), *In a Glass House* (McClelland & Stewart 1993), and *Where She Has Gone* (McClelland & Stewart 1998). *Lives of the Saints* was the winner in Canada of the SmithBooks/*Books in Canada* First Novel Award, the F. G. Bressani Prize, and the Governor General's Literary Award for fiction, and in England of the Betty Trask Award and the Winifred Holtby Memorial Prize. *Where She Has Gone* was shortlisted in Canada for the Giller Prize. Ricci's novel *Testament* will be published in 2002.

DAVID ADAMS RICHARDS has been named one of the ten best Canadian writers under the age of 45. Richards won the Canadian Authors Association Literary Award for Fiction in 1991 and the Canada-Australia Prize in 1992 for his important contribution to literature. He is a two time recipient of the Governor General's Literary Award — once for his novel *Nights Below Station Street* (McClelland & Stewart 1987) and once for his memoir *Lines on the Water: A Fisherman's Life on the Miramichi* (Doubleday 1998). He was recently named Author of the Year at the Libris Awards and his latest novel, *Mercy Among the Children* (Doubleday 2000), was co-winner of the Giller Prize.

J. JILL ROBINSON, from Langley, B.C., has lived in Saskatoon since 1993. She has published three collections of short stories, including *Saltwater Trees* (Arsenal 1991) and *Lovely in Her Bones* (Arsenal 1993), and has recently completed a fourth, *Residual Desire*. She is currently working on a creative non-fiction project that involves, in part, her family's history in Banff between 1923 and 1954. She studied literature at the University of Calgary (M.A.), and creative writing at the University of Alaska at Fairbanks (M.F.A.).

LEON ROOKE lives in Winnipeg. Most recent of Rooke's 28 books include *Painting the Dog: The Best Stories of Leon Rooke* (Thomas Allen 2001) and the novel *The Fall of Gravity* (Thomas Allen 2000). He has published more than 300 short stories and is represented in over 80 national and international anthologies. His novel *Shakespeare's Dog* (Stoddart 1982) won a Governor General's Literary Award and *Fat Woman* (Oberon 1980), another novel, won the Paperback Novel of the Year Award and was shortlisted for other prestigious awards.

RICHARD SCRIMGER has been publishing novels for adults and children since 1996. *The Nose from Jupiter* (Tundra 1998) won the Mr. Christie's Book Award. His most recent books are *Mystical Rose* (Doubleday 2000) and *Bun Bun's Birthday* (Tundra 2001).

SANDRA SHIELDS has worked as an editor and freelance writer, often collaborating with her husband, photographer David Campion. Their work has received honorable mention at the National Magazine Awards and a National Media Award from the Canadian Association for Community Living. With support from the International Centre for Human Rights and Democratic Development, they travelled to Namibia in 1996 to document the situation of the Himba tribe. Shields currently lives in Vancouver and is at work on a book about consumer culture.

RUSSELL SMITH grew up in Halifax and lives in Toronto. He is the author of the novels *How Insensitive* (Porcupine's Quill 1994) and *Noise* (Porcupine's Quill 1998). His most recent book, the story collection *Young Men* (Doubleday 1999), was shortlisted for the Toronto Book Award and the Danuta Gleed Literary Award. A widely published journalist, he writes the

weekly "Virtual Culture" column in the *Globe and Mail*. His next book, *The Princess and the Whiskheads*, will be published by Doubleday Canada in 2001.

ROBERT (BOB) STALLWORTHY, formerly a social worker, has been writing for 16 years. He has poetry in magazines and anthologies across Canada. He has given over 150 performances and workshops in Alberta schools. He was the first Calgary region co-ordinator for the Writers Guild of Alberta and is one of three lifetime members of the Writers Guild of Alberta.

FRED STENSON is a freelance writer of books and films. His most recent novel, *The Trade* (Douglas & McIntyre 2000), won the Grant MacEwan Author's Award, the Writers Guild of Alberta Georges Bugnet Award for Fiction, and was shortlisted for the Giller Prize. He has ten other published books and has written scripts for more than 130 produced films and videos. He was raised on a farm/ranch in the Waterton area of southwestern Alberta and now lives in Calgary.

DREW HAYDEN TAYLOR, an Ojibway from the Curve Lake First Nations, has worn many hats in his literary career. Over the last two decades, he has been an award-winning playwright, a journalist/columnist, short-story writer, scriptwriter, librettist, and more recently, a director of documentaries on Native culture for the National Film Board. Author of 11 books (soon to be 13), he looks forward to finding the time for laundry.

MICHAEL TURNER's books include *Hard Core Logo* (Arsenal 1993), *American Whiskey Bar* (Arsenal 1997) and, most recently, *The Pornographer's Poem* (Doubleday 1999). He has also written on the work of Brian Jungen,

Bruce LaBruce, and Ken Lum. Currently he is working with Stan Douglas on a script for the artist's upcoming installation, *Journey into Fear*. He lives in Vancouver.

ARITHA VAN HERK's award-winning novels and essays have been praised throughout North America and Europe. Her first novel, *Judith* (McClelland & Stewart 1978), received the prestigious Seal First Novel Award and her third novel, *No Fixed Address* (McClelland & Stewart 1986), earned a Governor General's Literary Award nomination and the Writers Guild of Alberta Howard O'Hagan Award for Short Fiction. Her other books include *The Tent Peg* (McClelland & Stewart 1981), *Places Far from Ellesmere* (Red Deer 1990), and *Restlessness* (Red Deer 1998). She is currently completing an irreverent history of Alberta.

ERIKA DE VASCONCELOS was born in Montreal and studied at McGill University. Her first novel, *My Darling Dead Ones*, was published by Alfred A. Knopf Canada in 1997. Her second novel, *Between the Stillness and the Grove* (Knopf), was published in September 2000. Her work has been translated into several languages. She has also published works of fiction in *Toronto Life* and *This* magazine. De Vasconcelos lives in Toronto and teaches creative writing at Humber College and at the Humber School for Writers.

FRED WAH has published poetry, prose-poems, biofiction, and criticism. His book of prose-poems, *Waiting for Saskatchewan* (Turnstone 1985), received the Governor General's Literary Award and *So Far* (Talonbooks 1991) was awarded the Writers Guild of Alberta Stephan G. Stephannson Award for Poetry. *Diamond Grill* (NeWest 1996), a biofiction about hybridity and growing up in a small-town Chinese-Canadian

café won the Writers Guild of Alberta Howard O'Hagan Award for Short Fiction. His most recent book, *Faking It: Poetics and Hybridity* (NeWest 2000), was awarded the Gabrielle Roy Prize for writing on Canadian literature.

THOMAS WHARTON was born in Grande Prairie, Alberta, and lived in Jasper for several years before moving to Edmonton to complete a B.A. and M.A. in English at the University of Alberta. He completed a Ph.D. in English at the University of Calgary in 1998, and now lives in Edmonton with his family. His first novel, *Icefields* (NeWest 1995), won numerous awards, including the Commonwealth Writer's Prize for Best First Book, Canada and Caribbean Regions. His latest novel, *Salmander: A Novel* (McClelland & Stewart) was published in 2001.

CHRISTOPHER WISEMAN's eighth book of poetry is *Crossing the Salt Flats* (Porcupine's Quill 1999). He has published widely in journals and anthologies and was founder of the creative writing program at the University of Calgary in 1973. He has taught writing in many places, including The Banff Centre. He lives in Calgary.

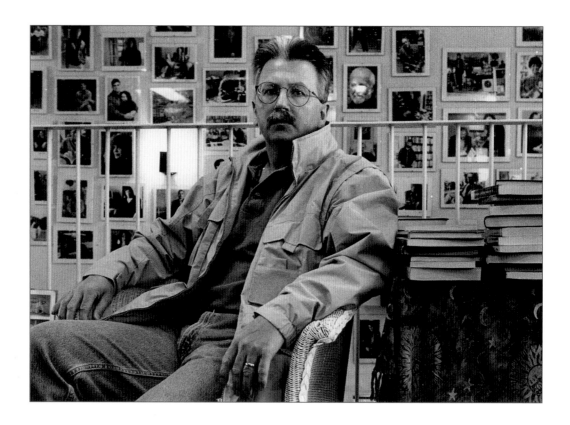

Don Denton

was born in Burnaby, B.C., and grew up in Maple Ridge, a then largely rural suburb of Vancouver. He started his photographic career in Kamloops, B.C., at the *Daily Sentinel* in 1977. Since then he has worked as a photographer and/or picture editor in Edmonton, Vancouver and Brussels, Belgium. In the mid-nineties, Denton edited and published his own photo magazine, *Deadline.* He currently lives in Calgary, where he is assistant photo editor for the *Calgary Herald* and a part-time instructor at Mount Royal College. He is husband to Joanne and father to Nicholas, Spencer and Cole. This is his first book.